WILLIAM WILHELMI
THE CLAY'S THE THING

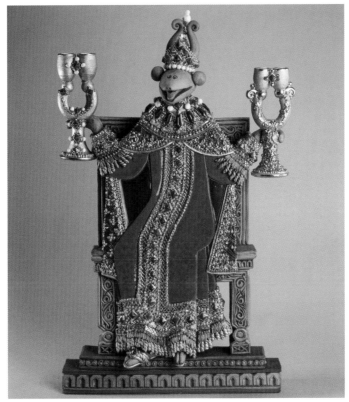

MONSTER TO THE TSARS, CEREMONIAL ICON I, 1996, stoneware, lustre.

March 8 - June 2, 1996

ART MUSEUM OF SOUTH TEXAS
1902 North Shoreline Drive
Corpus Christi, Texas 78401
Affiliated with Texas A&M University-Corpus Christi

CONTENTS

We appreciate the added historicity provided by Cathleen Gallander, Ric Collier and Lillian Murray, past directors of AMST, in their writing for this catalog.

Library of Congress Catalog No. 96-083027
ISBN 1-888581-00-X

This publication accompanies the exhibition "Wilhelmi: The Clay's The Thing," organized by The Art Museum of South Texas and guest curated by Ben Holland.

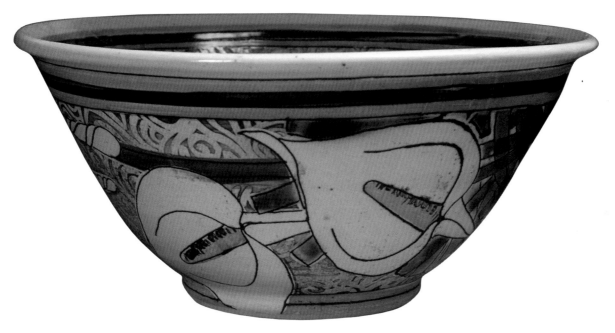

CALLA LILY BOWL, 1989, Stoneware, 5 ¹/₂ x 1 1 ³/₄, Private Collection.

Wilhelmi and associates in his studio: Wilhelmi, Molly Merkle, Doug Stenner, and Ed Gates. January, 1996.

Wilhelmi in Nepal on a potters' study program. February, 1993.

PATRONS OF THE EXHIBITION

AMERICAN BANK
Tiny and George Hawn
Helen and George Hawn, Jr.
Christina and Clayton Hoover
Patricia and Ben Wallace
Jennifer and Paul Caldwell
Jennifer and Robert Patterson
Julianna and Peter Holt
Laura and Tony Pletcher
Sandy and Mike McKinnon
Municipal Arts Commission

Madeline O'Connor
Martha Claire Tompkins
Patty and Tignor Thompson
Sondra and Celso Gonzalez-Falla
William David Jack, II
Madlyn and Anthony Constant
Joan and Bernard Paulson
Ann and David Coover
Tina and Chuck Anastos
Barbara and Jerry Silverman
Kenneth V. Rosier
Robin and Lou Carter
Sarah King (Blissie) Blair
Diana and Bill Otton
Mary D. Clark
Nelwyn and John Anderson
Darrell L. Barger
Lynda and Harris Kaffie

Lynda A. J. Jones
Joan and Jon Spradley
Candace and Jim Moloney
Marcy Sanchez-Hunter
Lou and Charles Kennedy
Annette and Mel Klein
Evelyn Lee
Barbara Parker
Bibi Dalrymple and Greg Reuter
Evie and David Feltoon
Aloe Tile Works
Kimberley Hall Seger
Gloria and Bob Furgason
Anne Aeby
Polly Lou and Bob Livingston
Alice Gabbard
Herschel A. Sessions

Wilhelmi at home in 1972.

Major Funding By

4

LENDERS TO THE EXHIBITION

American Bank, Corpus Christi, Texas
Tina and Chuck Anastos, Corpus Christi, Texas
Tonya Baxter, Austin, Texas
Pat Best and Tony Feher, Corpus Christi, Texas
Sarah King (Blissie) Blair, Corpus Christi, Texas
Brad Braune, San Antonio, Texas
Jency and Patrick Carson, Kerrville, Texas
David Starr Chapman, Corpus Christi, Texas
Connie Chappell, San Diego, California
Suzi Dunn, Austin, Texas
Sissy Farenthold, Houston, Texas
Tony Feher, New York, New York
George Finley III, Corpus Christi, Texas
Marlive Fitzpatrick, Corpus Christi, Texas
Tiny and George Hawn, Port Aransas, Texas
Helen and George Hawn, Jr., Naples, Florida
Mary and Ed Hoffman, Ingleside, Texas
Julianna and Peter Holt, Blanco, Texas
Christina and Clayton Hoover, Corpus Christi, Texas
Janet and Al Jones, Corpus Christi, Texas
Lynda and Harris Kaffie, Corpus Christi, Texas
Paula Kaffie, Corpus Christi, Texas
Joan and Lynn Lee, Rockport, Texas
Polly Lou and Bob Livingston, Victoria, Texas
Leon Loeb, Corpus Christi, Texas
Long Beach Museum of Art, California
Matthews and Branscomb, Corpus Christi, Texas
Michelle Merkle, Corpus Christi, Texas
Molly and Dickson Merkle, Corpus Christi, Texas
Linda Morgan, Refugio, Texas
Madeline O'Connor, Victoria, Texas
Jennifer and Robert Patterson, Corpus Christi, Texas
Laura and Tony Pletcher, Corpus Christi, Texas
The Renwick Gallery of the Smithsonian Institution, Washington, D. C.
Betty Roberts, Tucson, Arizona
Edwin Singer, Corpus Christi, Texas
Jon Snyder and Michael O'Hare, Corpus Christi, Texas
Michael Swantner, Corpus Christi, Texas
Patty and Tignor Thompson, Dallas, Texas
Martha Claire Tompkins, Houston, Texas
Mary Jane Victor, New York, New York
Susila Ziegler, Taos, New Mexico

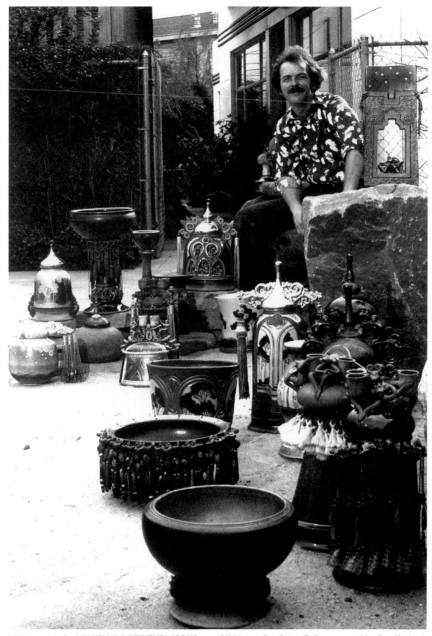

William ready for WILHELMI WITH THE WORKS, an exhibition at Dos Patos Gallery, curated by Ben Holland. May, 1975.

ACKNOWLEDGMENTS

This is the best of all times for me. (Saved it for last). It's Academy Awards night at AMST when I get to thank all those who have made this exhibition possible. First, I want to thank Dr. Bill Otton for having had the idea for the show and for asking me to guest curate it. Then, to the artist Bill Wilhelmi, who didn't ask for this show, but who went along with Dr. Otton and myself on this wild adventure to collect enough of his "history" to make an interesting presentation.

Let me also say thank you to everyone whose name appears in this catalog and many who don't. The museum staff was most helpful to me every step of the way. Amy Smith Kight worked with me on this show since the day she arrived at the museum, Beth Reese planned the creative educational programs, Marilyn Smith kept check on the details, Jerry Hartung created the setting and Melissa Goodson pursued the publicity. There was also a small army of volunteers who wanted to help. Chuck Anastos drew the plans for my dream temple, Mark Strand developed the checklist and directed the installation, Molly, Dickson and Marsden Merkle collected data and art work, Ed and Cornelia Gates, Doug Stenner, Greg Reuter, Ken Rosier, Barbra Riley and Louis Katz, among others, helped on production. Barbara McDowell was our proofreader. Opening night planners were Polly Lou Livingston, Lillian Murray, and Trey McCampbell.

We are indebted to the Smithsonian Institution for lending us their pair of Wilhelmi *Cowboy Boots* and to the Long Beach Museum of Art for *American Dream.* We are grateful for the enduring friendship of the Hawn family who underwrote a large portion of this exhibit from the outset. We are grateful to the owners of the largest collections of Wilhelmi ceramics, Jennifer Singer Patterson and Helen and George Hawn, Jr., for their willingness to share important pieces with us.

Finally, I want to bestow sainthood on Lynda A. J. Jones, who gave up being a "swinging single" to compose every word of this catalog on her computer (at night) with me looking over her shoulder. I wish to dedicate my portion of this work to our friends and patrons through the years and to the memory of a friend, Patsy Dunn Singer - benefactress to all who love art.

Ben Holland

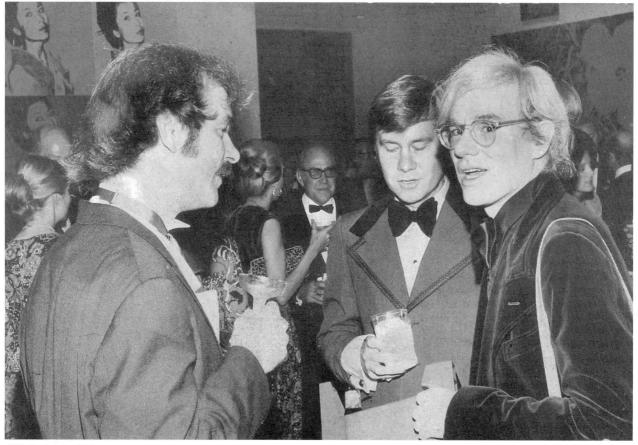

Bill Wilhelmi, Ben Holland and Andy Warhol at the grand opening of the Art Museum of South Texas, October, 1972.

INTRODUCTION

In 1969 William Wilhelmi arrived in Corpus Christi from Southern California to work as a designer for architect Richard Colley. Colley, who created a series of award winning buildings during his lifetime, was known for his high standards and expectations of those who worked with him. Wilhelmi, a recent graduate of UCLA, was selected to be one of those individuals.

From the beginning of his career in South Texas, Wilhelmi set THE standard of excellence for objects made of clay. This standard, which Colley saw prior to Wilhelmi's arrival has been an important element in Bill's ability to survive as an artist. It also relates to his evolution as a master artist in his chosen medium. While achieving artistic excellence has been a mainstay throughout Wilhelmi's career, lifetime commitment, a loyal patronage, "staying power" and personal aesthetic growth are also part of his success.

Art history is created when collectors and scholars identify and support the studio output of artists who, following self imposed high standards, expand the story of art. For example, Florentine artist, Luca della Robbia (1400-1482) and his son Andrea (1435-1525) made exquisite ceramic tiles to adorn Renaissance buildings. Their recognition as master artists is based on originality and their abilities to expand existing standards of artistic achievement in ceramic art into a new realm. The della Robbias' genius guided them as they pursued the creative process to make an object totally personal and unique, yet artistically connected to earlier works. It is at this moment when art history is created, extended and codified.

Wilhelmi is a master potter, for sure. He has always been a visible personality in the local art community. His major contributions to art, however, are the focus of the current exhibit.

The selected work on view reveals Wilhelmi's ability to appropriate existing images, designs, or concepts and translate them into new vocabulary which serve his artistic needs. As he manipulates the wet clay followed by glazes, fire and paint, his finished works extend what we know is possible in ceramic art. Not unlike the della Robbias, it is within this arena of activity that Wilhelmi has become a master artist.

Wilhelmi's success is most exciting when formal qualities of shape and design are merged with his unique approach to decoration, rich glazes and paint. Added to subject matter that sometimes ranges from the whimsical to the provocative, Wilhelmi's oeuvre proves that "the whole is more than the sum of the parts."

It has been a great pleasure to be part of the process which led to the current exhibition. Guest curator, Ben Holland and Associate Curator, Amy Smith Kight have worked closely with AMST staff, volunteers and many of Bill's patrons to create a memorable presentation. Of course, it is the artist who must receive the greatest THANK YOU, for it is through his work that we are informed about the potential of being human. To each person I am most grateful!

William G. Otton
Director

COWBOY BOOTS, 1980
Porcelain
15 1/2 x 4 3/4 x 11 1/2 (ea.)
Collection of the National Museum of American Art,
Smithsonian Institution.

WILLIAM WILHELMI: *IN SITU*

Way back in the grey dim dawn of time, when all things were new -- especially the Philip Johnson-designed Art Museum of South Texas, Bill Wilhelmi was the first local artist to have a one person show there. The date? March 8, 1973 -- exactly twenty-three years ago to the day and hour. The year before, he had won First Place in the Art Foundation Show at the Art Museum then located in the old Centennial Museum on Park Avenue in South Bluff Park. His winning entry was an elaborately decorated ceramic cake-plate entitled *Happy Birthday Mom.* That, then, became the title of the exhibition. So, here it is March 8, 1996 and Bill Wilhelmi is *in situ.* Once again *in place.*

I had the honor of curating and designing that 1973 show, thanks to director Cathleen Gallander; and now, thanks to director Bill Otton, who conceived *this* show, I have that honor again.

Every year in the springtime since childhood, I have had this overpowering urge to produce a classical drama -- as the Greeks would say -- "in an envelope of stage, scenery, props, costumes, actors and audience, or some of these." For ten years as a young drama professor and director at two colleges and a university, I was able to realize that dream. From the outset, I visualized this exhibition in a *temple setting* because so much of Wilhelmi's work has that feel to it.

So now, once again, in the spring of '96, the stage is set; and you, my poppets, complete the scene as the actors and the audience.

Ben Holland
Guest Curator

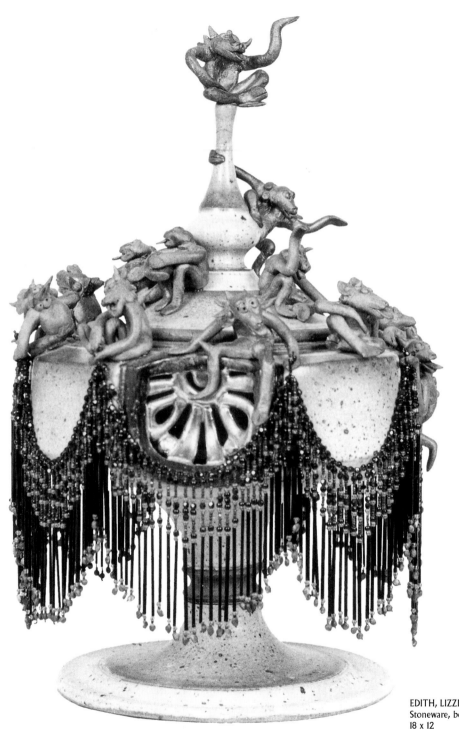

EDITH, LIZZIE, GRACE, CHARITY AND WATCHOUT, 1970
Stoneware, beads
18 x 12
Private Collection

WILLIAM WILHELMI, PRODIGAL POTTER

We're all mad here....
Lewis Carroll's "Cheshire Cat"

If, as Emerson maintained, "wit makes its own welcome, and levels all distinctions," small wonder the wit and charm of Bill Wilhelmi's work has garnered him several prestigious museum exhibitions throughout his career---exhibitions which, like the present retrospective, "level all distinctions." Some of those pesky "distinctions" which are summarily flattened in his unique and quite remarkable work include, among other things, discrepancies between scale, material, and the artist's ambitions and, first and foremost, the eternal hairsplitting over *fine art* and *craft.*

This artist's engaging enterprise has been, for decades now, a fascinating spectacle of one *very* mad potter plundering the history of art, and ransacking the museums, looking for challenge and inspiration---*and* for some quite dotty dialogue with the old masters he's encountered along the way. Almost all art-lovers are, to a greater or lesser degree, susceptible to Wilhelmi's work, on a number of levels; the Avon-bottle nut, the *avant-garde* aficionado, the olde-print-lover, even the Sèvres connoisseur, can find something compelling or diverting in this man's manic vision.

To my mind, one cottons to Bill Wilhelmi's undertaking if you're particularly beguiled by the *eccentrics* loitering down the long, shadowy corridors of the history of art. If you are drawn to the strange and strung-out Mannerists like Monsù Desiderio; if you love the capers in Callot's engravings of mayhem and madness; if you adore the topsy-turvy, but deeply intelligent world of Saul Steinberg; if you've tittered over the fin-de-siècle perversities of Félicien Rops, or shivered at the shenanigans in the paintings of Ensor, then you, Messieurs, are likely to

tumble to Bill Wilhelmi, and you Mesdames, are most definitely his target audience. Wilhelmi's world frequently transcends *mere clay* to the point we forget entirely the medium, and muse only on the message. (This, by the way, is one definition of virtuosity). The artist's angle of attack is always oblique, though generally ribald in the end. His vocabulary of forms and ornament leapfrogs along through the millennia of art, craft and architecture. His is an opulent, exuberant, sometimes obsessive take on key moments in the history of *décor,* of graphic design, and of *architecture*---of all things. And--- in the interstices, we can detect some pit-stops at "roadside attractions" and souvenir shops, too.

Edith, Lizzie, Grace, Charity & Watchout, of 1974, is an especially florid display of Wilhelmi's gift for creating elaborate table-top tours de force. Even more, it's a veritable summit conference of those lunatic, lolling "monsters" who've swarmed all over his universe for many years.

These grotesque critters (insinuating little *succubi* and *incubi* more often than not), clamber all over Wilhelmi's bottomless cupboards-full of *compôtes* and *macedoines* and *épergnes,* and cake-stands, chalices, cups and candelabra---and they are decidedly not *just* decorative. These tiny tableaus are usually pointing some moral (about "too-much-cake" or "too-much-wine," or "too-little-something-else"), or they're gleefully illustrating human follies and excesses.

But coasting on humor alone, and throwing off titillating l'il one-liners is not anywhere near enough for this prodigal potter. Wilhelmi's penchant is to decorate-to-death, *to fill the vacuum* with ornament and anecdote. This *horror vacui,* this congenital incapacity to subtract rather than add, has often been noted in Wilhelmi's work. In this regard, he is a prime example of those compulsive Islamic artists and artisans who animated every cubic inch of the Alhambra.

This inclination towards the Oriental, towards over-the-top opulence, is everywhere apparent in Wilhelmi's work these 30-odd years. Ogival arches and onion-domes—architectural forms, noteworthy—and tremulous, pendant decorations (i.e., those cascades of quivering beadwork) all suggest the artist may have had a prior existence in old Byzantium, or perhaps in the gaudy depths of the *hareem*. The lurid is clearly not unknown turf for this artist—he laps it up, as he does the whole history of art.

This artist, whether he knows it or not, is one of those rare persons who are struck by the miraculous in nearly every damn thing they encounter, and who can't help but capture it. Those wonderful old *cabinets of curiosities* of the Renaissance princes, overflowing with bizzareries like narwhale tusks and bezoars, jeweled mechanical toys, and paintings by the masters, are the proper milieu of this sort of prodigal mind. "Prodigies," "miracles," were avidly sought by princes then, and just as avidly fabricated *now,* by Bill Wilhelmi.

This is a baroque sensibility at work, an artist who, if he has a crazy conception, will, Willy-nilly, break all rules and overturn all conventions to give it one helluva go—in clay. Blurring the line between art and craft, fun and profundity, the dross and the precious, the solid object and the quirkiest idea—that's what this guy's a master at. (*And,* it's not at all inconceivable that, given the probable flood of tumbling shapes and ornaments that course incessantly across this artist's subliminal screen, many a *bozzetto* or masterpiece has bit the dust on the studio floor.

The disarming, insouciant work of Bill Wilhelmi constantly belies his command of his craft and his dedication to the

unending *industry* involved. Repeatedly, Wilhelmi has demurred when his work is called "art;" he even bristles at being called a "ceramist." But, wethinks he doth protest too much, given that his career has never faltered in the estimation of collectors and museums, and that his images have rarely missed their mark.

The artist's magical command of the air-brush, the deft way he transforms clay into the semblance of marble, leather, gemstones or other materials, and his willingness to assay the most difficult projects --- a towering, beaded lamp, a "mah-jongg table" bathed in lamplight and seduction --- can't be denied. *"Wit makes its own welcome,"* indeed; and who would not make room for such a gifted artist, such a funny guy --- here, and in the hereafter? We all need a break today, and Bill Wilhelmi always delivers....

Jan E. Adlmann

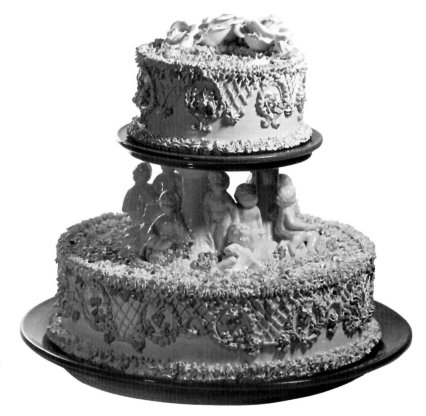

HAPPY BIRTHDAY MOM, 1972
Earthenware
12 1/2 x 15
Private Collection

FROM CATHLEEN

Bill Wilhelmi and I are twins! Well, sort of. We are both February 4th Aquarians, although admittedly, my Feb-Four arrival preceded his by a few years! Having said that however, it is my great honor to share a horoscope with this wonderful talent.

Wilhelmi's work always maintains the highest standards of craftsmanship. But more importantly, his ceramic pieces transcend craft. They are art in the highest sense of the word, art that makes aesthetic and social comments. Even his utilitarian objects have a presence of their own and reveal a highly individual, creative talent. Each piece reflects his rich, baroque style wonderfully endowed with his quirky, eccentric wit. Both the utilitarian and the non-utilitarian pieces become, as Madeline O'Connor once described them, "contemporary Dresden," wonderful objets d'art. His ceramics, from his whimsical monsters to his western boots to his animals and cactus and all of the other strange and eccentric creations, reflect a highly original talent producing work of the highest quality.

One of my favorite exhibitions as director of the Art Museum of South Texas was his *HAPPY BIRTHDAY MOM*. It was filled with beautiful and delicious-looking pastries, all from his own recipe book and stove. And all beautifully and imaginatively crafted with extraordinary glazes and sumptuous forms. It was a joyous presentation that made everyone feel good. What more can a museum director ask!

Bill Wilhelmi's contribution to the cultural life of Corpus Christi has been major. His work has brought imagination, humor, and a high standard of artistic endeavor to the community. This exhibition is a well-deserved tribute to his contributions.

Cathleen Gallander

A FLOWERED FORMAL JACKET, THE BEACH BOYS AND A GREMLIN

ALTERNATIVE adj. 1: ALTERNATE 2: offering or expressing a choice <several ~ plans> 3: existing or functioning outside the established cultural, social or economic system <~ life-style>

BILL WILHELMI: An artist, friend, advisor, and citizen. He is inquisitive, deliberate and compassionate.

Intense.
Perhaps contentious.
Perhaps ridiculous. Always provocative.
Never destructive or disingenuous.

A devotee.

A generous philanthropist to his family; to his relationship; to his community; to his art; to his craft.

Seldom compromised. Genuine. Authentic. Engaging. Eccentric. Playful. A thoughtful ally.

A peculiar catalyst in a peculiar town.

The patient, calculating visionary.

Optimist.
Exuberant.
Consummate instigator with a caustic sense of humor.

A social chameleon. Fragile.

A vulnerable and sensitive pioneer.

The quintessential human being.

Since meeting him along with Danny O'Dowdy and Roy Fridge at a "MEMBERS ONLY" preview at the AMST in the fall of 1980, I have been an ardent fan of Bill Wilhelmi.

Ric Collier

ENDURING MUD PIES

Is it sculpture? Is it pottery? Or is it simply the work of an eccentric sculpting potter making mud pies for a living? In truth, it is the best of all!

An image maker *par excellence,* Bill Wilhelmi uses clay for his canvas, transforming the commonplace into the uncommon. His work is not art as we know it in the traditional sense, rather a celebration of the people, places, and things we encounter in our everyday lives. The world as seen through Bill's eyes and hands brings both smiles and a sense of appreciation for the skill of the artist and his often humorous interpretations.

But what of the man himself? Is there a bit of the *Wilhelmi soul* to be found in the whimsical caricatures posturing upon his vessels? It's easy to spot Bill's exuberant spirit in the grinning faces of his quirky little monsters, each reflecting a facet of the nature of this man. Be it a bowl, a boot or beastie, the work is never contrived, but rather spontaneous, simple and ingenuous; always making a contiguous connection between the life we live and objects he forms.

Tuned in to his audience, Wilhelmi's work tells a story...evokes emotion...and comes to life. Each piece is a shaped composite of his life's experiences, expressing joy and appreciation for our rich culture and southern traditions. Evoking emotion, whether it be admiration of shape, form, or pattern or the pleasure in simply having physical contact with a Wilhelmi piece, there is always exhilaration in ownership.

Just as Elton John sang "...my gift is my song and this one's for you..." so too, Bill shares his gifts with us through his artistic celebration of life's little pleasures. Enjoy him, for his time is now.

Lillian Murray

NON-NIMBUS NUMBER NINE, 1973
Earthenware
18½ h x 12 w x 7d
Collection of Ben Holland

ST. IGNATIUS AT PALACIOS, 1977
Earthenware
15 1/2 h 8 1/2 w x 5 h
Collection of Jennifer Singer Patterson

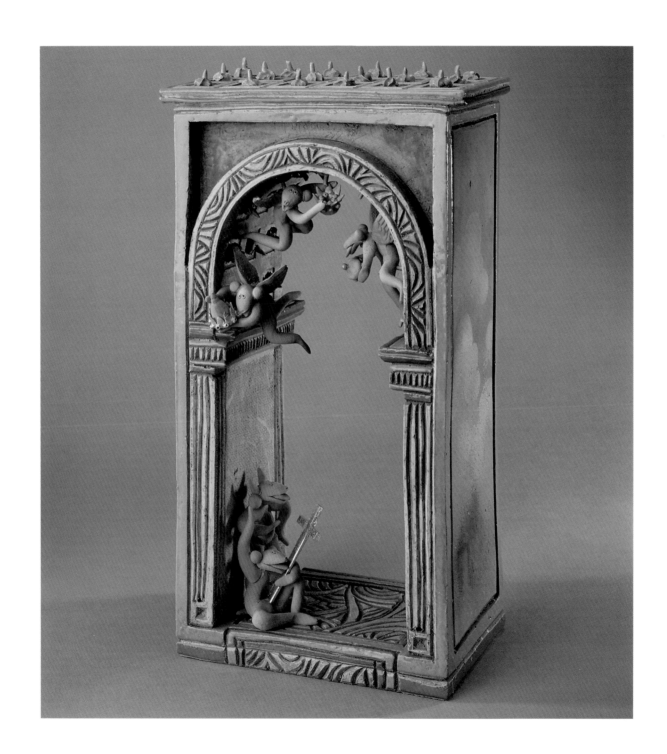

THE NAKED MAH-JONGG TABLE LAMP, 1983
Earthenware, wire, fabric
12 h x 8 w x 5 d
Collection of Helen and George Hawn, Jr.

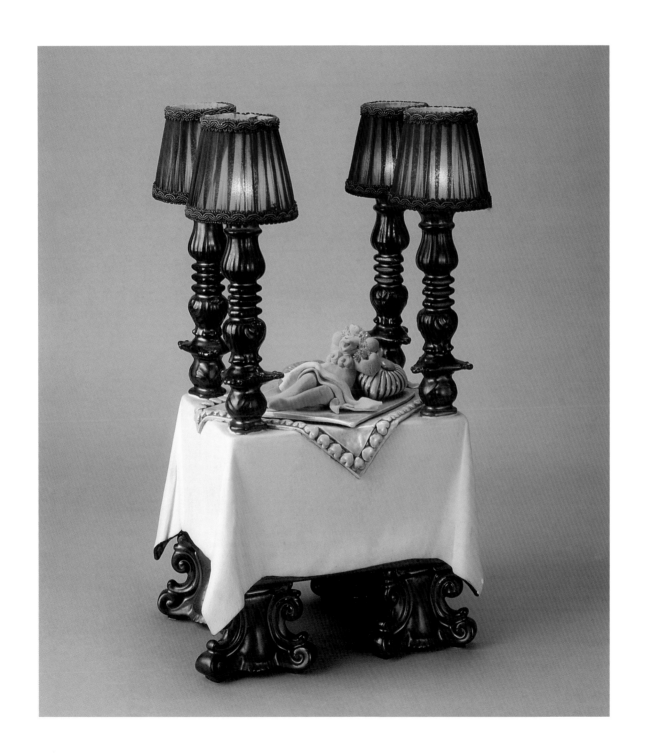

BANANA LEAF MOTIF URN, 1988
Earthenware
23 h x 13 d
Collection of Tina and Chuck Anastos

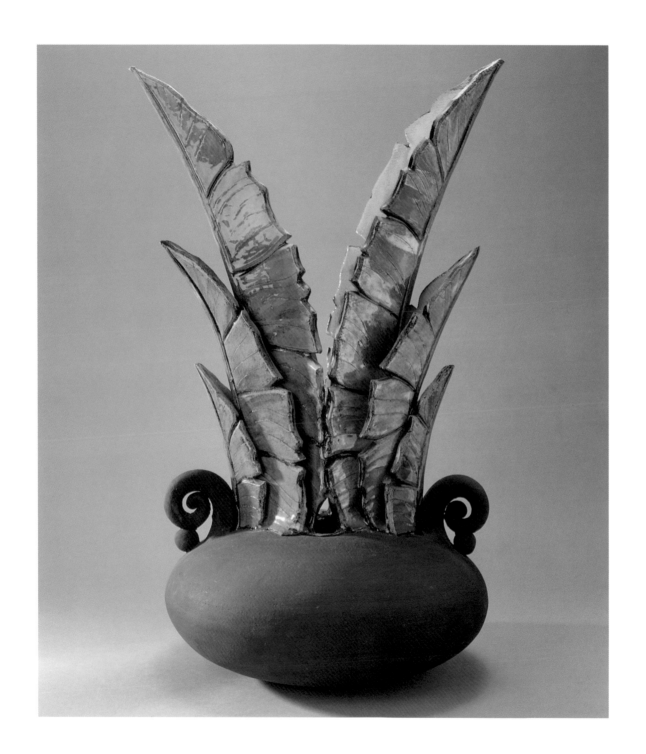

EXHIBITION CHECKLIST

height precedes width or diameter
all sizes are in inches
some pieces are multimedia

COWBOY BOOTS, 1980
porcelain
15 1/2 X 4 3/4 11 1/2 (ea.)

HAPPY BIRTHDAY MOM, 1972
earthenware
12 1/2 x 15

RENWICK ANNIVERSARY CAKE, 1982
earthenware
17 3/4 x 15

THE SWINGERS, 1975
stoneware
14 1/2 x 9 1/2

PHRA MEHA MONGUT, 1972
earthenware
28 x 9 1/2

ELEVATED BEADED ROCK, 1970
stoneware
18 3/4 x 8 1/2

STILETTO BOOTS, 1984
earthenware
7 1/4 x 8 1/4

THE FLYING WALLENDAS, 1973
stoneware
12 x 9

THE FLYING WALLENDITAS, 1971
stoneware
9 1/4 x 6

THE EARTH ABOVE, THE SKY BELOW,
1972
earthenware
10 1/4 x 10 1/4 x 7

ORIENTAL SPLENDOR, 1977
earthenware
21 x 10 x 4 1/4

MONSTER MOTHER WITH PUP, 1978
stoneware
12 1/4 x 8

A PHOENIX UNFREQUENT, 1972
earthenware
8 3/4 x 13

EDITH, LIZZIE, GRACE, CHARITY AND
WATCHOUT, 1970
stoneware
18 x 12

ELEVATED TREEPOT, 1972
stoneware
22 x 9

JENNIFER'S BIRTHDAY CAKE, 1981
earthenware
11 1/2 x 8

NAKED MAH-JONGG LAMP, 1983
earthenware
19 x 11 x 8

SAINT IGNATIUS AT PALACIOS, 1977
earthenware
15 1/2 x 8 1/2 x 5

BANANA LEAF MOTIF URN, 1988
earthenware
23 x 12 3/4

NON-NIMBUS NUMBER NINE, 1973
earthenware
18 1/2 x 12 x 7

LIDDED DAMSON JAR, 1974
stoneware
19 x 14

TASSELLED, WINGED LAMP, 1977
earthenware
26 x 11

DOMED ROCK CROCK, 1976
stoneware
10 1/2 x 8

OPHELIA OPENING NIGHT, 1975
stoneware
8 3/4 x 12 1/2 x 7

CLAUDE, 1972
earthenware
16 x 7 1/2

RED POPE OF RUSSIA, 1984
stoneware
20 x 12

TO MARKET, TO MARKET, TO BUY A
FLAT PIG, 1977
earthenware
12 x 10 1/4 x 8

FARRAH FEATHERS, 1979
earthenware
16 1/2 x 9

GILT COMPLEX, 1974
stoneware
16 x 10

CRYSTAL MADONNA, 1985
earthenware
19 1/2 x 11 3/8

TEXAS TEAPOT, 1987
earthenware
8 1/4 x 8 x 7

MUSEUM PIECE, 1978
earthenware
14 1/8 x 11 3/8 x 9

NITE ON THE NILE, 1977
earthenware
14 3/4 / x 9 x 7

CUMULUS CLOUDS WITH MONSTERS,
1975
earthenware
15 1/4 x 13 x 10 1/2

BANANA VASE (PAIR), 1981
stoneware
17 1/8 x 8

LEI HOLDER, 1977
earthenware
20 1/2 x 12 1/4 x 8 1/2

TURKISH TUREEN, 1977
raku
15 1/4 x 14 x 11

EASTER LILY, 1985
earthenware
11 3/4 x 7 x 8

CHOCOLATE CAKE, 1981
earthenware
9 1/2 x 11

GUY DE MONSTER, 1984
stoneware
18 x 18 1/2 x 10

HALF-N-HALF BOWL, 1977
stoneware
5 3/4 x 11 1/4

CORONATION MONSTER, 1992
stoneware
15 x 7 1/2 x 9

FACE VASE, 1978
stoneware
7 3/4 x 10

RETURN OF THE ROCKETTES, 1978
stoneware
12 1/4 x 9

LACE VASE, 1994
stoneware
10 1/4 x 6 1/4

CALLA LILY BOWL, 1989
earthenware
5 1/2 x 11 3/4

ELEVATED, BEADED HORS D'OEUVRE
DISH, 1973
earthenware
44 1/4 x 15 1/2

ELEVATED, BEADED COMPOTE (3), 1994
earthenware
22 3/4 x 10

BEADED, TASSELLED LAMP, 1973
earthenware
27 1/4 x 9

TEXAS TEAPOT, 1987
earthenware
10 1/2 x 9 1/2 x 7 1/2

JUNE TAYLOR DANCERS, 1972
stoneware
4 x 12 3/4

LITTLE BLUE VASE, c.1969
stoneware
6 1/4 x 6 1/2 x 6 1/4

PILLOW POT, 1985
earthenware
6 1/2 x 16 3/4 x 14 1/2

ELEVATED, BEADED ROCK CROCK, 1974
stoneware
15 1/4 x 9 1/8

MONSTER CANDELABRUM, 1969
stoneware
10 1/8 x 4

MONSTER CANDELABRUM, 1971
stoneware
11 x 4 1/2

ELEUTHERIAN CAKE PLATE, 1975
earthenware
26 3/4 x 9

GEOMETRIC BOWL, 1973
stoneware
7 3/4 x 11 3/8

NITE OF THE STARS, 1982
earthenware
18 1/4 x 11 3/4 x 10 1/4

MONSTERS GETTING OFF THEIR ROCKS,
1975
stoneware
12 x 14 x 9

SCENIC SCREEN, 1987
stoneware tile
28 1/4 x 30 1/2

FLYING MONSTER LAMP, 1979
earthenware
31 x 12

FIRST COMMISSIONED CHURCH, 1970
earthenware
21 x 18

THREE PEAS IN A POD PILLOW, 1988
earthenware
6 x 16

PERSIAN POTS (3), 1995
stoneware
31 1/2 x 17 approx.

QUASI-COLOMBIAN, ALMOST
AFRICAN, 1971
stoneware
15 x 13 1/2 x 11

DANCING WATERS, 1969
earthenware
22 x 12

LADIES AT TEA TAFFEL, 1988
stoneware
22 x 30 x 1

RAINBOW POT, c.1969
earthenware
9 x 7 1/2

MONSTER POT, c.1969
stoneware
8 x 9 1/4

MISS MONSTER CANDELABRA, 1995
stoneware
13 x 6 x 9

ADMIRAL CRICHTON, 1979
stoneware
20 x 12

SINGAPORE SLING, 1973
stoneware
16 x 8 x 5

TONGALELE MONSTER, 1994
stoneware
22 x 15 x 9 1/4

TITILLATING MONSTER, 1994
stoneware
22 x 15 x 9 1/4

ALAMO SCREEN, 1986
(with Danny O'Dowdy)
stoneware tile and wood
66 x 72

AMERICAN DREAM, 1973
earthenware and metal
11 1/2 x 6

TAFFEL #1: MONSTERS SITTING IN
THEIR STUDIO AT SÈVRES, 1974
stoneware
12 x 11 x 1 1/2

TAFFEL #42: LOUNGING ON THE
LOGGIA AT THE LOUVRE, 1975
stoneware
12 x 11 x 1 1/2

TAFFEL #19: EVENING IN EUPHORBIAS,
1973
stoneware
12 3/8 x 12 3/8 x 1

TAFFEL #35: PROMENADE BEFORE THE
PARADE, 1974
stoneware
12 3/8 x 12 3/8 x 1

AURORA (NEOCLASSICAL), 1989
earthenware
43 x 22 x 5 1/2

PETITS FOURS, 1973, 1996
earthenware
varied

MONSTER IN MINK, 1979
stoneware
20 x 12

ROTUNDA, 1972
earthenware
15 x 7 $^1/_2$

PEAS IN POD GOBLETS (2), 1990
earthenware
13 x 6

MUSTARD JAR, 1979
earthenware
11 x 10

ORIGINAL MONSTER LA PAZ, 1968
earthenware
7 x 7 x 3

MONSTER MOTHER, 1978
stoneware
13 x 8 $^1/_2$ x 8

BE MINE BOUDOIR BOX, 1981
earthenware
10 $^3/_4$ x 7 $^1/_4$ x 5 $^3/_4$

STARRY NIGHT GOBLETS (4), 1995
earthenware
9 $^3/_4$ x 4 (ea.)

BOUDOIR JAR, 1992
earthenware
7 $^7/_8$ x 12 $^3/_8$ x 8 $^3/_4$

CACTI CANDELABRA, 1995
earthenware
5 x 13 $^1/_2$

ASSORTED MINIATURES, 1990-1996
stoneware
varied

CHRISTMAS ORNAMENTS, 1979-1995
earthenware

MONSTERS TO THE TSARS
SERIES, 1996:

CEREMONIAL ICON, I
stoneware
25 x 16 x 5

SACRAMENTAL ICON, II
stoneware
22 $^3/_4$ x 10 $^3/_4$ x 4

SACRIFICIAL ICON, III
stoneware
22 $^3/_4$ x 10 $^3/_4$ x 4

SACERDOTAL ICON, IV
stoneware
23 x 11 x 4

SANCTIMONIOUS ICON, V
stoneware
22 $^1/_2$ x 10 x 6

SANCTIFIED ICON, VI
stoneware
23 x 11 x 4

SAINTLY ICON, VII
earthenware
23 $^1/_2$ x 10 $^3/_4$ x 4 $^1/_2$

JEWELED DINNERWARE FOR THE
TSARS, 1996
stoneware
varied

CEREMONIAL JEWELED VASE, 1996
stoneware
16 $^1/_2$ x 9 x 9

CEREMONIAL JEWELED VASE, 1996
stoneware
22 $^1/_2$ x 10 1/2 x 10 $^1/_2$

ASSORTED JEWELED BOXES AND
PETITS FOURS, 1996
earthenware
varied

Kaffie Gallery at the Carancahua Compound opened September 18, 1976.

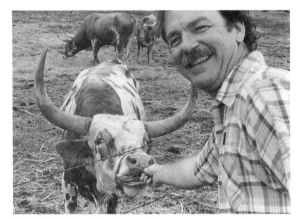

Field Trip, c. 1979.

Artists at Kaffie Gallery, c. 1979. Standing: Wayland Randolf, David Chapman, Bill Otton, Bill Wilhelmi. Seated: Greg Reuter and Danny O'Dowdy.

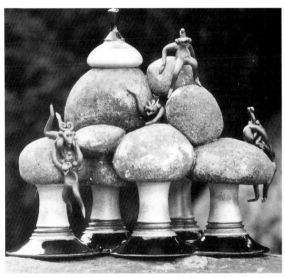

MONSTERS GETTING OFF THEIR ROCKS, 1975
Stoneware
12 x 14 x 9
Collection of Linda Morgan

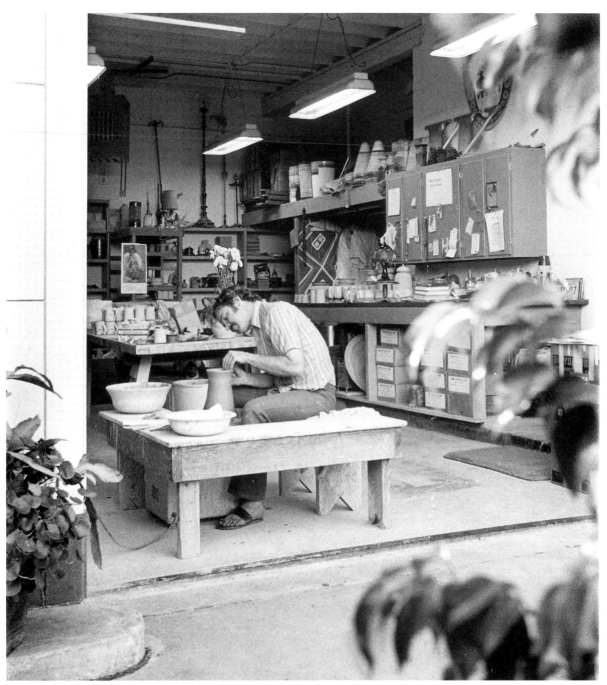

Wilhelmi working in his studio at Dos Patos Gallery in the Colley compound on Tancahua Street, c. 1970.

DOS PATOS AND BEYOND
A Brief Historical Survey By Ben Holland

"When I need inspiration, I get on a jet plane." -- the artist, 1970

Bill Wilhelmi first arrived in Corpus Christi on a jet plane in 1969 to interview for a job as studio potter to an architect. He was met at the airport by Stewart Colley, whose father was to hire Wilhelmi. He was then driven into the city by a very circuitous route. There was no expressway at the time and the idea was to avoid entering the city via Agnes Street. So, after a few back roads and little-used bridges, the grand entrance was made over the high bridge. This, Stewart reasoned, would give Wilhelmi a more spectacular first impression of Corpus Christi. And it did. He was carefully shepherded around the city for the weekend, introduced to the best that the city had to offer, and he fell in love with Corpus Christi. By now he has seen much more of this town but still probably wouldn't live any place else. His pottery studio was in the garage part of a renovated Gulf service station which was in the Colley compound on Tancahua Street. Soon after his arrival, the rest of the building became Dos Patos Gallery and a show-room for his work. Wayland "Tinker" Randolf was his chief assistant. Wayland was a self-taught potter who had learned to throw by reading "how to" in a book. Not easy. In those six years with Margaret and Richard Colley as benefactors, Wilhelmi had plenty of time to do his thing, enter shows, jet off to shows, become known throughout the land and a celebrity in his own city.

I met Wilhelmi in 1970 when I was director of the Little Theatre. He came out to work backstage and we became friends. My first assignment with and for Wilhelmi was naming the pieces for his shows, then curating and designing *HAPPY BIRTHDAY MOM* at the Art Museum. In 1975, I had become director of Dos Patos Gallery. At the end of that year, we were approached by Charles and Harris Kaffie, two young entrepreneurs and very good clients, to develop a studio and gallery situation at the old Kaffie homestead on Carancahua Street. It was designed by budding California architect and early post-modern proponent Andrew Batey and proved to be quite a showpalace. The three car garage was enlarged and became Wilhelmi's studio. The two story house became the Kaffie Gallery and I was its director. The original budget for the entire transformation was $10,000. The final project cost $90,000 -- and that was in 1976. The construction began in January of that year and was completed in September with a huge gala opening featuring Wilhelmi and Victoria artist Madeline O'Connor. Madeline had measured all the walls and created sky paintings to fit the walls in three galleries. The clouds floated over Wilhelmi table settings and the show was entitled *PICNIC: PAINTINGS AND POTTERY.*

In 1977, I organized a show around some touring cowboy boots by the old grandfather Cosimo Lucchese who had migrated to the United States in the 40's. In fact, Jan Ernst von Adlmann (who was then director of the Long Beach Museum of Art and had given Wilhelmi a one person show with top billing over Marc Chagall) had discovered the then extant 22 pairs of boots and declared them museum pieces. (He organized the touring show for museums and galleries). Each pair of boots represented one of the then forty-eight states with carefully sewn leather tops depicting the state capitol, state bird , flag, flower, etc. Wilhelmi wanted to fit into this show (entitled *COWBOYS & COSIMO*) and went to a flea market, bought an old pair of well-worn boots for three dollars, made a mold of the boots, cast them, airbrushed them with a gorgeous West Texas sunset and put them in the exhibit. It was a onetime thing so far as he was concerned -- his first and last pair of ceramic cowboy boots. Now the boots reside in museums around the country, "every" home and office in Corpus Christi, Saks Fifth Avenue windows in New York, Ralph Lauren boutiques around the country, and at the Renwick Gallery of the National Museum of Art of the Smithsonian Institution in Washington D. C. And that latter pair is in this exhibition -- the only pair ever made out of porcelain. In 1979, Lloyd Herman, director of the Renwick Gallery (across the street from the White House and next door to Blair House), saw Wilhelmi's boots at a New York gallery on Madison Avenue, across the street from the Whitney. He wanted them for an exhibition he was developing on *AMERICAN PORCELAIN* and asked Wilhelmi if he could do the same in porcelain. He could. The image of the boots became the poster for the show in Washington and again when the show toured the United States. And, well, you know the rest.

We had attracted quite a few artists to our spectacular setting and among them was the young head of the art department at CCSU, Dr. Bill Otton, whom everyone called Dr. Dotton because he was a colorist who painted with dots of color straight from the tube. Also, Danny O'Dowdy, who was a hippie professor at Texas A&I University in Kingsville, and Greg Reuter, who was the curly-headed new pottery instructor at CCSU; even the great James Surls of Splendora and Michael Tracy of San Ygnacio, who had the reputation of being somewhat of an *enfant terrible*. Be that as it may, everything Tracy touched turned to art. The gallery and studio worked together on shows. When I would plan an exhibit, Wilhelmi would come up with ideas for pieces to fit that theme. *POTS AND PRINTS OF POTS* was such a show. Wilhelmi took his inspiration from antique prints to create showpieces.

We had many wonderful and beautiful shows (I'll show you my scrapbook) but the thing that always sold best and consistently was the Wilhelmi pottery. By

now, we felt -- and still do, that everyone in town must have a houseful. (We've raided some of those homes to create this exhibition). Wilhelmi continued to have shows around the country and he would get on a jet plane and go to them all.

In 1983, the Kaffie Gallery closed. Sad, but in all those seven years of great artists, great shows and great crowds, the owners had not realized one dime of profit. In fact, *au contraire*. But, as luck would have it, an affluent couple, young and charming, who had been among our best customers, were anxious to be gallery owners. Martha and Guy Demange took over the gallery after Wilhelmi and I had flown to Santa Fe to visit them and make the final pitch. Wilhelmi continued to do his thing and I worked with the Demanges as director of the Carancahua Gallery. The Demanges were very hands on and we attracted more great artists --- from Houston, New York -- all around. And still, seemingly what our audiences wanted most was Wilhelmi's work. All this time, Wilhelmi just wanted to be a potter. Seeming never to run out of fuel for new work, he thus enjoyed one of an artist's greatest gifts -- the free flow of new ideas. We continued to have large crowds at openings -- which had, from the beginning, been somewhat of a phenomenon.

In 1986, our beautiful, melon-colored, Batey-designed paradise, with cloistered walls, brick parking lot, red tile roof and beautiful gardens, was to become a restaurant. We had to get out! So, ten years to the day later, on September 18, 1986, we moved to our present location on Chaparral Street. We borrowed $10,000 from Al Jones at the American Bank to make this old building (which had been a Studebaker-Packard showroom in its day and had lain dormant for twenty years) into our new studio and gallery. We divided it into halves. One end was Wilhelmi's studio, the other end was my gallery. I decided, very cleverly, I believe, to call my end of the building Wilhelmi / Holland Gallery and to this day everyone thinks it's Wilhelmi's. And to a great extent that accounts for its success. We continue to fill those Corpus Christi homes with ceramics and art, we continue to have large crowds at our openings, and we continue to attract wonderful artists whose work we show. And, since the move, the gallery has always operated in the black. Wilhelmi's studio associates who made the move with us were Ed Gates (a graduate of Kansas City Art Institute) and the late and much missed Gumecindo Larios. Joining the scene most recently have been Molly Merkle, Doug Stenner and sometimes Michelle Merkle.

When I first got to know Wilhelmi, he didn't know how to throw a plate. He had graduated from UCLA in 1969 during the reign of Ronald Reagan as governor of California and there had been the influence of Peter Volkos & company at Otis

Institute and Scripps College (in the 50's). So, Wilhelmi had come to his new job in Corpus Christi able to make beautiful "useless" objects. They looked like they could be or should be functional but they weren't. He was a wheel oriented potter, so his objects had some of that familiar look but with an abundance of adornment. Cake plates that looked like a cake but would never see one, soup tureens that were too shallow for soup, oil and vinegar sets that came in their own carrying case, teapots dripping with beadwork; all beautiful, all fascinating, all nonfunctional.

After he had settled into his new studio at Dos Patos, Wilhelmi's first assignment by his new benefactor and boss, the renowned architect Mr. Colley, was a set of dishes. Wilhelmi was horrified. But he accepted the challenge and learned to make a plate -- and a cup -- and a bowl -- and a goblet -- but still decorated with those beautiful, time consuming motifs. He would (and still does) use easy stroke and airbrush on earthenware and wax resist and sgraffito on stoneware. You may not know the process, but you know the result. He would bring those ordinary objects to life with his landscapes of eucalyptus trees, sunsets, cows and cacti, calla lilies and geometric designs. When he arrived from California, he had three design concepts that have since become his trademarks. To wit, his eucalyptus tree landscapes, the "rock" formations, and the "monsters." (Those critters are called "monsters" because the first one was a cross between a Gila monster and an alligator). He had been persuaded to do an "animal" while a student one summer in La Paz, Mexico. So, the granddaddy of all "monsters" was born. They have evolved over the years becoming ever more human and friendly. Some people love them and some hate them, but they endure.

I retired from my career in theatre in 1972. For the last twenty-five years I have enjoyed a life as art aficionado and gallery director in connection with Wilhelmi's pottery studio. We have had wonderful benefactors -- many of whom are listed in this catalog. When I curated *HAPPY BIRTHDAY MOM*, Wilhelmi had been a studio potter for three years. Now, for this show, he has been a studio potter for twenty-seven years and has produced a prodigious amount of amazing work. *THE CLAY'S THE THING* can only hint at what the man has been able to create in those years.

Here we are, you and I, at the threshold of a new century. As we open this twenty-five year survey of the work of William Wilhelmi, I feel we are just beginning. And the potter from Dos Patos, so many years and jet flights later, continues to apply his talent to clay, to the delight of his wide and eager audience.

BIOGRAPHY

Born 1939, Garwin, Iowa
Reared in San Diego, California
Resides in Corpus Christi, Texas

Education:
M.F.A. University of California, Los Angeles, 1969
B.A. San Diego State University, 1960

Special Studies:
Centro De Arte Regional, La Paz, Baja California, Mexico, 1967
Haystack Mountain School of Arts & Crafts, Deer Isle, Maine, 1968
Anderson Ranch Tour, "Exploring With the Potters of Nepal," 1993

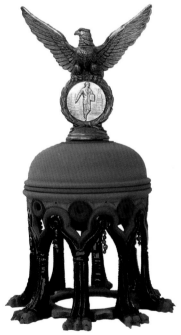

AMERICAN DREAM, 1973
Earthenware, beads, metal
15 x 6 ¹/₂
Collection of Long Beach Museum of Art

Museum Collections:
Long Beach Museum of Art, Long Beach, California
Everson Museum of Art, Syracuse, New York
Tweed Museum of Art, Duluth, Minnesota
Renwick Gallery of the Smithsonian Institution, Washington, D. C.
Cooper-Hewitt Museum, New York City
Gene Autry Museum of Western Art, Los Angeles, California
Wustum Museum of Fine Art, Racine, Wisconsin
Art Museum of South Texas, Corpus Christi, Texas

Listed In:
Who's Who in American Art, 1980-1996
Who's Who in Society, 1986
The Chicago Art Review, 1989
The New York Art Review, 1989
The Southwest Art Review, 1990
American Artists, 1990
Who's Who in the South and Southwest, 1995-96
Who's Who in the World, 1996

BIBLIOGRAPHY

Publications:

DECORATIVE ART IN MODERN INTERIORS, Ed. Maria Schofield, Van Nostrand Reinhold, London, 1970-78.

CERAMIC DESIGN, 1975.

CLAYWORK: FORM AND IDEA IN CERAMIC DESIGN, Leon Nigrosh, Davis Publishing, Worchester, MA, 1975.

CONTEMPORARY CERAMIC TECHNIQUES, 1977.

CERAMICS, Glenn Nelson, Holt Rinehart Winston, 1978.

WHO'S WHO IN AMERICAN ART, Ed. Jacques Cattell, Bowker, NY, 1980-1996.

TEAPOTS, Rick Berman, 1980.

PORCELAIN TRADITIONS AND NEW VISIONS, Jan Axel & Karen McReady, Watson Guptill, NY, 1980.

AMERICAN PORCELAIN: NEW EXPRESSIONS IN AN ANCIENT ART, Renwick Gallery of the Smithsonian Institution, Washington, DC, 1981.

CERAMICS OF THE 20TH CENTURY, Tamara Preaud & Serge Gauthier, (English and French versions), Rizzoli, New York and Paris, 1982.

AMERICAN COWBOY, Lon Taylor & Ingrid Maar, Library of Congress, Washington, DC, 1983.

CERAMICS, Philip Rawson, published 1971 by Oxford University Press, republished 1984, University of Pennsylvania Press.

WHO'S WHO IN SOCIETY, Ed. David Wilcox, American Pub., FL, 1986.

THE NEW YORK ART REVIEW, Ed. Les Krantz, American References, Chicago, 1989.

THE CHICAGO ART REVIEW, American References, Chicago, 1989.

THE SOUTHWEST ART REVIEW, American References, Chicago, 1990.

AMERICAN ARTISTS, American References, Chicago, 1990.

AMERICAN CERAMICS, Everson Museum of Art, Syracuse, NY, Rizzoli, NY, 1990.

THE BOOK OF CUPS, Garth Clark, Abbeville Press, NY, 1990.

WHO'S WHO IN THE SOUTH AND SOUTHWEST, Marquis Who's Who, New Providence, NJ, 1995-96.

WHO'S WHO IN THE WORLD, Marquis Who's Who, New Providence, NJ, 1996.

ART TODAY, Edward Lucie-Smith, Phaidon, London, GB, 1996.

BIBLIOGRAPHY

Periodicals:

HOME MAGAZINE, "Concepts in Ceramics," Los Angeles Times, August, 1971.

CRAFT HORIZONS, "Exhibitions," February, 1975.

HOUSE BEAUTIFUL'S HOME DECORATION, "American Crafts," Winter, 1978-79.

STUDIO POTTER, "A Conversation with William Wilhelmi," Volume 8, Number 2, 1980.

TEXAS MONTHLY, "These Boots Weren't Made for Walking," December, 1980.

CORPUS CHRISTI MAGAZINE, "A Cowboy Christmas," December, 1980.

TOWN & COUNTRY, "Shopper's Guide," December, 1981.

TOWN & COUNTRY, "Corpus Christi Lone Star Pearl," May, 1982.

AMERICANA, "The American Cowboy," March-April, 1983.

AIRBRUSH DIGEST, "Texas Potter," May-June, 1983.

SIGNATURE, "Cowboys and Indians," September, 1983.

SOUTHERN LIVING, "A Gallery of Cowboy Boot Pottery," July, 1984.

METROPOLITAN HOME, "Upstairs-Downstairs," March, 1988.

MERIAN, (Hamburg, Germany), Boot Frontispiece, September, 1988.

CELESTIAL IMAGES, Smithsonian Engagement Calendar, 1988.

ARCHITECTURAL RECORD, "Government Writ Large," January, 1989.

AMERICAN ART RUMMY, Card Game, National Museum of American Art, Washington, D. C., 1990.

ULTRA, "At The Water's Edge," August, 1989.

VERANDA, "El Jacalito in the Texas Hills," Spring, 1994.

HOMES, "South Texas Style," Corpus Christi Caller -Times, July 17, 1994.

HOMES, "Wilhelmi: Still an Exciting Potter after 25 Years," Corpus Christi Caller-Times, July 24, 1994.

SUNDAY HOMES, "South Texas Style," Corpus Christi Caller-Times, September 4, 1994.

CERAMICS: ART AND PERCEPTION, "Texas Clay," Review by Maria Ziegler, Sydney, Australia, Issue 17, 1994.

SELECTED EXHIBITIONS

"25th Ceramic National," Everson Museum of Art, Syracuse, New York, 1968

"California Crafts VI," Crocker Art Gallery, Sacramento, California, 1969

"Young Americans," University of New Mexico and Museum for Contemporary Crafts, New York, Traveling 1969-1971

"California Design XI," Pasadena Art Museum, California, 1971

"The Intricate Object," Long Beach State College Galleries, California, 1972

"New Acquisitions," Long Beach Museum of Art, California, 1973

"Arts/Objects: USA," Limited Editions, Lee Nordness and Johnson's Wax, New York, New York, 1973

"Happy Birthday Mom," One Man Show, Art Museum of South Texas, Corpus Christi, 1973

"Baroque '74," Museum for Contemporary Crafts, New York, New York, 1974

"Ceramic Exhibition," Whitney Museum Downtown, New York, New York 1974

"16th Texas Crafts Exhibition," Dallas Museum of Fine Arts, Texas, 1974

"Consciously Beautiful Objects," Nordness Gallery, New York, New York, 1974

"Craft Multiples," Renwick Gallery of the Smithsonian, Washington, D.C., 1975

"Bowl Show," Yaw Gallery, Bloomfield Hills, Michigan, 1975

"Texas Crafts as Art," Laguna Gloria Art Museum, Austin, Texas, 1975

"Wilhelmi With the Works," Dos Patos Gallery, Corpus Christi Texas, 1975

"Picnic: Paintings and Pottery," Inaugural Exhibition, Kaffie Gallery, Corpus Christi Texas, 1976

"Let's Drink To It," The Elements Gallery, Greenwich, Connecticut, 1977

"From Nature," The Elements, Gallery of Contemporary Crafts, New York, New York 1978

"20th Century Ornament," Cooper-Hewitt Museum, New York, New York, 1978

"Texas Designer Craftsmen Show," Southwest Craft Center, San Antonio, Texas, 1978

"Contemporary America," South Texas Art Mobile, Corpus Christi, 1979

"Stoneware," Contemporary Artisans, San Francisco, California, 1979

SELECTED EXHIBITIONS

"Texas Clay," Weil Gallery, Corpus Christi State University, Texas, 1979

"A Potter's Dozen," NCECA Conference, Ann Arbor, Michigan, 1980

"For The Table Top," Contemporary Crafts Museum, New York, New York, 1980

"American Porcelain," Renwick Gallery, Smithsonian, Washington, D.C., 1980

"Hill's Gallery In High Gear," Santa Fe, New Mexico, 1981

"Cowboys--The New Look," Marilyn Butler Gallery, Scottsdale, Arizona, 1981

"Limited Editions -'81," The Elements Gallery, New York, New York, 1981

"Inedible Cakes, Celebrating the Renwick's 10th Birthday," Renwick Gallery,
 Smithsonian Institution, Washington, D.C., 1982

"American Cowboy," Library of Congress, Washington, D.C., 1983

"Twelve Contemporary Artists," Cayman Gallery, New York, New York, 1983

"Decorative Surface," Carancahua Gallery, Corpus Christi, Texas, 1985

"Scenic Clay," NCECA Exhibition, Charlton Art Gallery, San Antonio, Texas, 1986

"Transpositions-Collaborations," (with Michael Tracy), San Antonio Art Institute,
 Texas, 1986

"Contemporary Teapots 200," Springfield Art Association, Illinois, 1987

"Reuter & Wilhelmi," The Living Desert Museum, Palm Desert-Indian Wells,
 California, 1989

"Wilhelmi: Neo-Classical Clay," Emily Edwards Gallery, Southwest Craft
 Center, San Antonio, Texas, 1989

"Room With A Few: Artists," Wilhelmi / Holland Gallery, Corpus Christi, Texas, 1994

"Feast For The Eyes," Austin Museum of Art at Laguna Gloria, Texas, 1996

"Braune & Wilhelmi," Nave Museum of Art, Victoria, Texas 1996

"Wilhelmi: The Clay's The Thing," Art Museum of South Texas, Corpus Christi, 1996

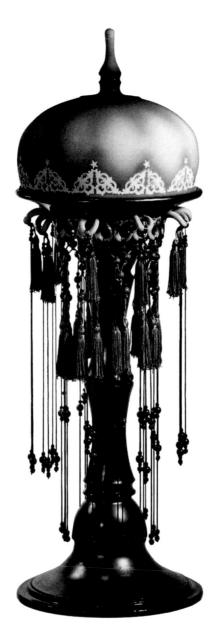

PHRA MEHA MONGUT, 1972
Earthenware, beads, tassels, macramé
28 x 9 1/2
Collection of Lynda & Harris Kaffie

MUSEUM STAFF

William G. Otton, Director
Marilyn Smith, Assistant Director
Marilyn Parson, Administrative Secretary
Amy Smith Kight, Associate Curator / Registrar
Beth Reese, Curator of Education
Diana Sepulveda, Bookkeeper
Lou Ellen Adler, Gift Shop Manager
Jennifer Smith, Gift Shop Sales
Jerry Hartung, Preparator
Deborah Fullerton-Ferrigno, Outreach Coordinator
Gary Gorton, Installer
Raul Budd, Maintenance
Melissa Goodson, Publicist
Eva Smith, Workstudy Education Assistant
Eugene Castillo, Security
Richard Castro, Security
Jesse Contreras, Security
Justo Godines, Security
Guilevaldo Longoria, Security

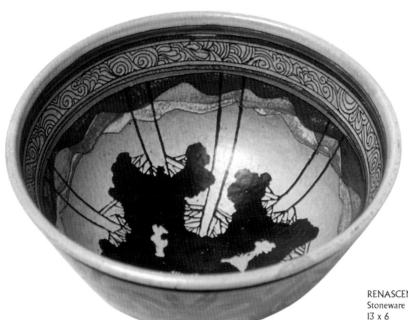

RENASCENCE BOWL, 1990
Stoneware
13 x 6
Private Collection

43

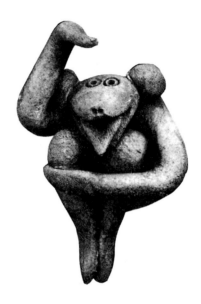

WILHELMI: THE CLAY'S THE THING catalog was
composed by Lynda Jones in Monotype Albertus
on a Macintosh computer. Lithography by Grunwald
Printing Company. Designed by Ben Holland.

PHOTOGRAPHIC CREDITS

Raymond Gray: pp. 1,21,23,25,27, back cover
Ronald Randolf: pp. 6,12,16,32,44
Louis Katz & Barbra Riley: p. 3 (bowl),
inside back cover
Glenn Maupin: p. 31 (Field Trip)
Lala Salazar: inside front cover (Wilhelmi)
James Farmer: p. 31 (artists)

Heliotrope & Taupe, 1996

Addendum to the Catalog

CHECKLIST

Height precedes width in all dimensions.

A PHOENIX UNFREQUENT, 1972
earthenware
8 3/4 in. x 13 in.
Private Collection

ADMIRAL CRICHTON, 1979
stoneware
20 in. x 12 in.
Collection of Sue Sellors Finley

ALAMO SCREEN, 1986
(with Danny O'Dowdy)
stoneware tile and wood
66 in. x 72 in.
Collection of Julianna and Peter Holt

THE AMERICAN DREAM, 1973
mixed media
15 in. x 6 1/2 in. x 6 1/2 in.
Collection of the Long Beach Museum of Art,
 Gift of the Museum Association of the Long Beach
 Museum of Art
 72-3.55

AMERICAN MONSTER, n.d.
mixed media
22 3/4 in. x 8 in. x 7 1/4 in.
Collection of American Bank

ASSORTED HEART AND MONSTER BOXES
earthenware
varied sizes
Private Collection

ASSORTED JEWELED BOXES AND PETIT FOURS,
1996
earthenware
varied sizes
Courtesy of Wilhelmi/Holland Gallery

ASSORTED MINIATURES, 1990-1996
stoneware
varied sizes
Courtesy of Wilhelmi/Holland Gallery

AURORA (NEOCLASSICAL), 1989
earthenware
43 in. x 22 in. x 5 1/2 in.
Collection of Tina and Chuck Anastos

AZCAPOTZALCO, 1977
stoneware
15 in. x 6 1/2 in. x 4 in.
Private Collection

BANANA LEAF MOTIF URN, 1988
earthenware
23 in. x 12 3/4 in.
Collection of Tina and Chuck Anastos

BANANA VASE (PAIR), 1981
stoneware
17 1/8 in. x 8 in.
Collection of Martha Claire Tompkins

BE MINE BOUDOIR BOX, 1981
earthenware
10 3/4 in. x 7 1/4 in. x 5 3/4 in.
Collection of Ben Holland

BEADED LAMP, 1981
earthenware
20 in. x 11 in.
Collection of Mr. and Mrs. Clayton J. Hoover

BEADED LAMP, 1994
earthenware
20 in. x 11 in.
Collection of Jennifer and Robert Patterson

BEADED LAMP, 1994
earthenware
25 1/2 in. x 12 in.
Collection of Cynthia and Thomas Wilder

BEADED, TASSELLED LAMP, 1973
earthenware
27 1/4 in. x 9 in.
Collection of the Artist

BOUDOIR JAR, 1992
earthenware
7 7/8 in. x 12 3/8 in. x 8 3/4 in.
Courtesy of Wilhelmi/Holland Gallery

CACTI CANDELABRA, 1994
earthenware
5 in. x 13 1/2 in.
Collection of Janet and Al Jones

CALLA LILY BOWL, 1989
stoneware
5 1/2 in. x 11 3/4 in.
Collection of Ben Holland

CANDELABRA WITH TASSELS AND SHELLS, 1979
stoneware
19 in. x 11 in.
Private Collection

CARSON'S CAKE, 1995
(with Ben Livingston)
mixed media
15 1/4 in. x 12 1/2 in.
Collection of Jency and Patrick Carson

CEREMONIAL JEWELED VASE, 1996
stoneware
16 1/2 in. x 9 in. x 9 in.
Courtesy of Willhelmi/Holland Gallery

CEREMONIAL JEWELED VASE, 1996
stoneware
22 1/2 in. x 10 1/2 in. x 10 1/2 in.
Courtesy of Wilhelmi/Holland Gallery

CHOCOLATE CAKE, 1981
earthenware
9 1/2 in. x 11 in.
Private Collection

CHRISTMAS ORNAMENTS, 1979-1995
earthenware
varied sizes
Collection of Ed and Cornelia Gates
(Estate of Gumecindo Larios)

CLAUDE, 1972
earthenware
16 in. x 7 1/8 in.
Private Collection

CORONATION MONSTER, 1992
stoneware
15 in. x 7 1/2 in. x 9 in.
Collection of Michelle Merkle

COWBOY BOOTS, 1980
glazed porcelain
15 1/2 in. x 4 3/4 in. x 11 1/2 in. (ea.)
Collection of the National Museum of American
 Art, Smithsonian Institution, Gift of William
 Wilhelmi

CRYSTAL MADONNA, 1985
earthenware
19 1/2 in. x 11 3/8 in.
Collection of Jennifer Singer Patterson

CUMULUS CLOUDS WITH MONSTERS, 1975
earthenware
15 1/4 in. x 13 in. x 10 1/2 in.
Collection of Jennifer Singer Patterson

DANCING WATERS, 1969
earthenware
22 in. x 12 in.
Collection of Connie Chappell

DESIGN PLATES, 1974
earthenware
1 in. x 12 in.
Collection of Michael and Susan Swantner

DICKSON'S TEMPLE, 1984
earthenware
13 1/4 in. x 7 in.
Collection of Molly and Dickson Merkle

DOMED ROCK CROCK, 1976
stoneware
10 1/2 in. x 8 in.
Estate of Mikel Fackenthall

THE EARTH ABOVE, THE SKY BELOW, 1972
earthenware
10 1/4 in. x 10 1/4 in. x 7 in.
Collection of Patsy and Edwin Singer

EASTER LILY, 1985
earthenware
11 3/4 in. x 7 in. x 8 in.
Private Collection

EDITH, LIZZIE, GRACE, CHARITY AND
WATCHOUT, 1970
stoneware
18 in. x 12 in.
Private Collection

ELEVATED BEADED ROCK, 1970
stoneware
18 3/4 in. x 8 1/2 in.
Collection of Lynda and Harris Kaffie

ELEVATED, BEADED COMPOTE, 1994
earthenware
22 3/4 in. x 10 in.
Private Collection

ELEVATED, BEADED COMPOTE, 1994
earthenware
22 3/4 in. x 10 in.
Collection of Jennifer and Robert Patterson

ELEVATED, BEADED COMPOTE, 1994
earthenware
22 3/4 in. x 10 in.
Collection of the Art Museum of South Texas,
 Gift in Honor of Elizabeth and David Richter

ELEVATED, BEADED HORS D'OEUVRE DISH, 1973
earthenware
44 1/4 in. x 15 1/2 in.
Private Collection

ELEVATED, BEADED ROCK CROCK, 1974
stoneware
15 1/4 in. x 9 1/8 in.
Private Collection

ELEVATED TREEPOT, 1972
stoneware
22 in. x 9 in.
Collection of Polly Lou and Robert Livingston

ELEUTHERIAN CAKE PLATE, 1975
earthenware
26 3/4 in. x 9 in.
Collection of Wilhelmi/Holland Gallery

FACE VASE, 1978
stoneware
7 3/4 in. x 10 in.
Collection of J. Duane Holman

FARRAH FEATHERS, 1979
earthenware
16 1/2 in. x 9 in.
Collection of Leon Loeb

FIRST COMMISSIONED CHURCH, 1970
earthenware
21 in. x 18 in.
Collection of Mrs. Robert Blair

FLYING MONSTER LAMP, 1979
earthenware
31 in. x 12 in.
Collection of Jon Snyder and Michael O'Hare

THE FLYING WALLENDAS, 1973
stoneware
12 in. x 9 in.
Collection of Patsy and Edwin Singer

GEOMETRIC BOWL, 1973
stoneware
7 3/4 in. x 11 3/8 in.
Private Collection

GILT COMPLEX, 1974
stoneware
16 in. x 10 in.
Private Collection

GUY DE MONSTER, 1984
stoneware
18 in. x 18 1/2 in. x 10 in.
Collection of Helen and George Hawn, Jr.

HALF-N-HALF BOWL, 1977
stoneware
5 3/4 in. x 11 1/4 in.
Collection of Joan and Jon Spradley

HAPPY BIRTHDAY MOM, 1972
earthenware
12 1/2 in. x 15 in.
Collection of Wilhelmi/Holland Gallery

HEART BOXES, 1995
earthenware
2 in. x 3 in. x 2 3/4 in.
Collection of Marsden Crescentia Merkle

HEART CANDELABRUM, 1993
earthenware
10 1/2 in. x 6 in. x 4 in.
Collection of Jency and Patrick Carson

JENNIFER'S BIRTHDAY CAKE, 1981
earthenware
11 1/2 in. x 8 in.
Collection of Jennifer Singer Patterson

JEWELED DINNERWARE FOR THE TSARS, 1996
stoneware
varied sizes
Courtesy of Wilhelmi/Holland Gallery

JUNE TAYLOR DANCERS, 1972
stoneware
4 in. x 12 3/4 in.
Collection of the Artist

JUPITER IN THE GUISE OF DIANA SEDUCING
CALLISTO, 1989
earthenware
30 in. x 18 in.
Collection of Kimberley and Bernard Seger

LACE VASE, 1994
stoneware
10 1/4 in. x 6 1/4 in.
Collection of Wilhelmi/Holland Gallery

LADIES AT TEA TAFFEL, 1988
stoneware
22 in. x 30 in. x 1 in.
Collection of Sissy Farenthold

LAUREL CANDLE RING HOLDER, n.d.
stoneware
4 in. x 9 in.
Collection of Tonya Baxter

LEI HOLDER, 1977
earthenware
20 1/2 in. x 12 1/4 in. x 8 1/2 in.
Private Collection

LIDDED DAMSON JAR, 1974
stoneware
19 in. x 14 in.
Collection of Tonya Baxter

LITTLE BLUE VASE, c. 1969
stoneware
6 1/4 in. x 6 1/2 in. x 6 1/4 in.
Collection of Tiny and George Hawn

LOTUS CANDLESTICKS (PAIR), n.d.
earthenware
21 in. x 10 in. x 9 in.
Collection of Paula Kaffie

LOVE IT OR LEAVE IT, 1970
earthenware
13 in. x 8 in.
Private Collection

MAKING A POINT OF POINTILLISM, n.d.
earthenware
18 3/4 in. x 9 in. x 7 in.
Private Collection

MAYFAIR'S CAKE STAND, c. 1973
earthenware
18 in. x 10 in.
Private Collection

MISS MONSTER CANDELABRAS, 1995
stoneware
13 in. x 6 in. x 9 in.
Collection of Tony and Laura Pletcher

MONSTER CACHEPOT, n.d.
stoneware
10 in. x 15 in.
Collection of Susila Ziegler

MONSTER CANDELABRA, 1969
stoneware
10 1/8 in. x 4 in.
Collection of Ben Holland

MONSTER CANDELABRA, 1971
stoneware
11 in. x 4 1/2 in.
Collection of Ben Holland

MONSTER FRAME WITH TASSELS, n.d.
earthenware
7 in. x 8 1/2 in. x 2 in.
Collection of Ben Holland

MONSTER IN MINK, 1979
stoneware
20 in. x 12 in.
Collection of Betty Roberts

MONSTER JOKER BOX, 1987
earthenware
7 in. x 5 7/8 in.
Collection of Tonya Baxter

MONSTER MIRROR, 1981
earthenware
2 in. x 21 in.
Collection of Tina and Chuck Anastos

MONSTER MIRROR, n.d.
earthenware
3 in. x 9 3/8 in.
Collection of Ben Holland

MONSTER MOTHER, 1978
stoneware
12 1/2 in. x 8 in. x 7 1/2 in.
Collection of Jennifer Singer Patterson

MONSTER MOTHER WITH PUP, 1978
stoneware
12 1/4 in. x 8 in.
Collection of Paula Kaffie

MONSTER POT, c. 1969
stoneware
8 in. x 9 1/4 in.
Collection of Pat Best

MONSTERS CAVORTING AT THE COURTHOUSE, 1983
stoneware
22 1/2 in. x 11 1/2 in. x 10 1/2 in.
Private Collection

MONSTERS GETTING OFF THEIR ROCKS, 1975
stoneware
12 in. x 14 in. x 9 in.
Collection of Linda Morgan

MONSTERS TO THE TSARS SERIES, 1996:
Courtesy of Wilhelmi/Holland Gallery

 CEREMONIAL ICON, I
 stoneware
 25 in. x 16 in. x 5 in.

 SACRAMENTAL ICON, II
 stoneware
 22 3/4 in. x 10 3/4 in. x 4 in.

 SACRIFICIAL ICON, III
 stoneware
 22 3/4 in. x 10 3/4 in. x 4 in.

 SACERDOTAL ICON, IV
 stoneware
 23 in. x 11 in. x 4 in.

 SANCTIMONIOUS ICON, V
 stoneware
 22 1/2 in. x 10 in. x 6 in.

 SANCTIFIED ICON, VI
 stoneware
 23 in. x 11 in. x 4 in.

 SAINTLY ICON, VII
 earthenware
 23 1/2 in. x 10 3/4 in. x 4 1/2 in.

MUSEUM PIECE, 1978
earthenware
14 1/8 in. x 11 3/8 in. x 9 in.
Collection of Jennifer Singer Patterson

MUSTARD JAR, 1979
earthenware
11 in. x 10 in.
Private Collection

NAKED MAH-JONGG LAMP, 1983
earthenware
19 in. x 11 in. x 8 in.
Collection of Helen and George Hawn, Jr.

NITE OF THE STARS, 1982
earthenware
18 1/4 in. x 11 3/4 in. x 10 1/4 in.
Collection of Helen and George Hawn, Jr.

NET ROCK, 1975
stoneware
13 1/2 in. x 9 1/2 in.
Private Collection

NITE ON THE NILE, 1977
earthenware
14 3/4 in. x 9 in. x 7 in.
Collection of Jennifer Singer Patterson

NON-NIMBUS NUMBER NINE, 1973
earthenware
18 1/2 in. x 12 in. x 7 in.
Collection of Ben Holland

OPHELIA OPENING NIGHT, 1975
stoneware
8 3/4 in. x 12 1/2 in. x 7 in.
Private Collection

ORIENTAL SPLENDOR, 1977
earthenware
21 in. x 10 in. x 4 1/4 in.
Collection of Paula Kaffie

ORIGINAL MONSTER LA PAZ, 1969
earthenware
7 in. x 7 in. x 3 in.
Collection of the Artist

PEAS IN POD GOBLETS, 1990
earthenware
13 in. x 6 in.
Collection of the Artist

PERSIAN POTS, 1995
stoneware
31 1/2 in. x 17 in. approx.
Collection of Matthews and Branscomb, P.C.

PERSIAN POT, 1995
stoneware
31 1/2 in. x 17 in.
Courtesy of Wilhelmi/Holland Gallery

PETIT FOURS, 1973
earthenware
1 3/4 in. x 7 1/2 in.
Collection of Mary Jane Victor

PETIT FOUR, 1973
earthenware
1 3/4 in. x 7 1/2 in.
Collection of Jennifer Singer Patterson

PETIT FOUR, 1981
earthenware
2 1/2 in. x 10 in. x 6 3/4 in.
Collection of David Starr Chapman

PETIT FOUR, 1973
earthenware
2 1/2 in. x 8 in.
Collection of Madeline and Thomas M. O'Connor

PETITS FOURS, 1981
earthenware
3 1/2 in. x 6 in.
Collection of Marlive E. Fitzpatrick

PHRA MEHA MONGUT, 1972
earthenware
28 in. x 9 1/2 in.
Collection of Lynda and Harris Kaffie

PILLOW POT, 1985
earthenware
6 1/2 in. x 16 3/4 in. x 14 1/2 in.
Collection of Ben Holland

POMEGRANATE PARFAIT, 1976
earthenware
15 in. x 10 1/2 in.
Private Collection

PRINCE OF LIGHT (GOMMIE), 1991
stoneware
18 1/2 in. x 12 3/4 in. x 11 in.
Private Collection

QUASI-COLOMBIAN, ALMOST AFRICAN, 1971
stoneware
15 in. x 13 1/2 in. x 11 in.
Collection of Madeline and Thomas M. O'Connor

RAIN TREE BLOSSOM HOLDER, 1976
stoneware
15 1/2 in. x 18 1/2 in. x 9 in.
Private Collection

RAINBOW POT, c. 1969
earthenware
9 in. x 7 1/2 in.
Collection of Pat Best

RED POPE OF RUSSIA, 1984
stoneware
20 in. x 12 in.
Collection of Leon Loeb

RENWICK ANNIVERSARY CAKE, 1982
earthenware
17 3/4 in. x 15 in.
Private Collection

RETURN OF THE ROCKETTES, 1978
stoneware
12 1/4 in. x 9 in.
Courtesy Wilhelmi/Holland Gallery

ROTUNDA, 1972
earthenware
15 in. x 7 1/2 in.
Private Collection

SAINT IGNATIUS AT PALACIOS, 1977
earthenware
15 1/2 in. x 8 1/2 in. x 5 in.
Collection of Jennifer Singer Patterson

SAPPHO (AFTER EGYPTIAN FLAGON), 1989
earthenware
54 in. x 23 in. x 5 1/2 in.
Private Collection

SCENIC SCREEN, 1987
stoneware tile
28 1/4 in. x 30 1/2 in.
Collection of Joan and Lynn Lee

SINGAPORE SLING, 1973
stoneware
16 in. x 8 in. x 5 in.
Collection of Sue Sellors Finley

STARRY NIGHT GOBLETS, 1995
earthenware
9 3/4 in. x 4 in. (ea.)
Private Collection

STILETTO BOOTS, 1984
earthenware
7 1/4 in. x 8 1/4 in.
Private Collection

THE SWINGERS, 1975
stoneware
14 1/2 in. x 9 1/2 in.
Collection of Linda Morgan

TAFFEL #1: MONSTERS SITTING IN THEIR
STUDIO AT SÈVRES, 1974
stoneware
12 in. x 11 in. x 1 1/2 in.
Collection of Leon Loeb

TAFFEL #19: EVENING IN EUPHORBIAS, 1973
stoneware
12 3/8 in. x 12 3/8 in. x 1 in.
Private Collection

TAFFEL #35: PROMENADE BEFORE THE
PARADE, 1974
stoneware
12 3/8 in. x 12 3/8 in. x 1 in.
Private Collection

TAFFEL #42: LOUNGING ON THE LOGGIA AT
THE LOUVRE, 1975
stoneware
12 in. x 11 in. x 1 1/2 in.
Collection of Leon Loeb

TASSELLED, WINGÈD LAMP, 1977
earthenware
26 in. x 11 in.
Collection of Tonya Baxter

TEENSY'S CAKE, 1985
earthenware
8 in. x 10 in.
Collection of Mr. and Mrs. Clayton J. Hoover

TEXAS TEAPOT, 1987
earthenware
8 1/4 in. x 8 in. x 7 in.
Collection of Jennifer Singer Patterson

TEXAS TEAPOT, 1987
earthenware
10 1/2 in. x 9 1/2 in. x 7 1/2 in.
Collection of the Artist

TIFFANY TREE, 1971
earthenware
16 1/2 in. x 8 1/4 in.
Private Collection

THREE PEAS IN A POD PILLOW, 1988
earthenware
6 in. x 16 in.
Collection of Brad Braune

TITILLATING MONSTER, 1994
stoneware
22 in. x 15 in. x 9 1/4 in.
Collection of Helen and George Hawn, Jr.

TO MARKET, TO MARKET, TO BUY A FLAT PIG,
1977
earthenware
12 in. x 10 1/4 in. x 8 in.
Collection of Leon Loeb

TONGALELE MONSTER, 1994
stoneware
22 in. x 15 in. x 9 1/4 in.
Collection of Mary and Edward Hoffman

TURKISH TUREEN, 1977
raku
15 1/4 in. x 14 in. x 11 in.
Private Collection

TURQUOISE BEADED VASE, 1993
stoneware
11 in. x 13 1/4 in. x 9 in.
Collection of Tina and Chuck Anastos

W STUDIO COMMEMORATIVE PLATE, 1976
stoneware
2 in. x 14 in.
Private Collection

WEDDING CAKE, 1978
earthenware
26 in. x 16 in.
Collection of James McCormick and Texas Enfield, Inc.

Xi RING DISH, 1984
stoneware
5 1/4 in. x 3 5/8 in.
Collection of Suzi Dunn